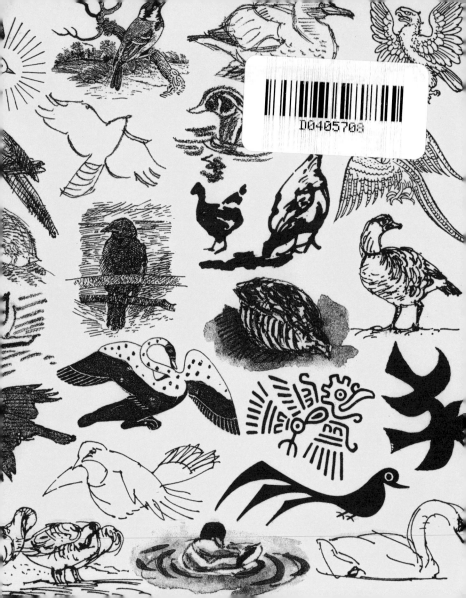

WAYS
OF
DRAWING
Birds

66 Day after day,
never fail to draw something
which, however little it may be,
will yet in the end be much, 99
and do thy best.

Cennino Cennini c.1390

WAYS
OF
DRAWING

Birds

A guide to expanding your visual awareness

RUNNING PRESS
PHILADELPHIA, PENNSYLVANIA

Produced, edited, and designed by Inklink, Greenwich, London, England.

Canadian representatives: General Publishing Co., Ltd., 30 Lesmill Road, Don Mills, Ontario M3B 2T6.
International representatives: Worldwide Media Services, Inc., 30, Montgomery Street, Jersey City, New Jersey 07302.

9 8 7 6 5 4 3 2 1
Digit on the right indicates the number of this printing.

CONSULTANT ARTISTS AND EDITORIAL BOARD
Concept and general editor, Simon Jennings
Main contributing artist, Richard Bell
Anatomical artist, Michael Woods
Natural history illustration advisor, John Norris Wood
Art education advisor, Carolynn Cooke
Design and art direction, Simon Jennings
Text editors, Ian Kearey and Albert Jackson
Historical research, Chris Perry

Typeset in Akzidenz Grotesque and Univers by Inklink
Image generation by T. D. Studios, London
Printed by South Sea International Press, Hong Kong

This book may be ordered by mail from the publisher.
Please add $2.50 for postage and handling.
But try your bookstore first!

Running Press Book Publishers
125 South Twenty-Second Street
Philadelphia, Pennsylvania 19103-4399

WAYS OF DRAWING BIRDS,
a guide to expanding
your visual awareness

Copyright © 1994 by Inklink

This edition first published in the United States by Running Press Book Publishers.

Library of Congress
Catalog Number
93-085536

ISBN 1-56138-396-1

CONTENTS

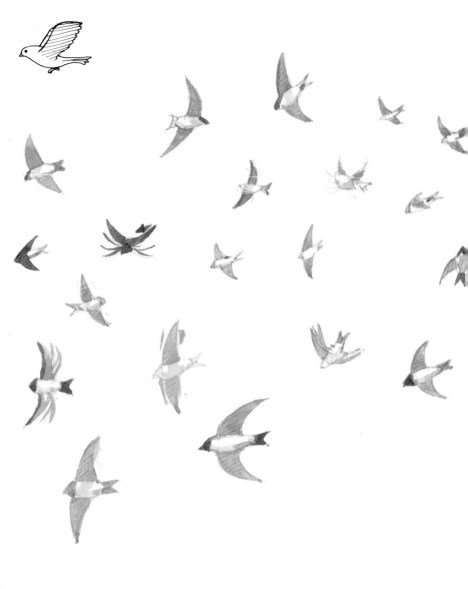

Introduction From the earliest times, mankind has been fascinated by birds' beauty and their seemingly magical powers of flight, and artists have depicted them in endless different ways and in a vast number of habitats. There is immense pleasure and satisfaction to be gained by drawing and observing birds, but it is often only too easy to be dazzled and confused by the varied and complex problems presented by these wonderful, nervous creatures, who seldom stay still – the mass of detail of the feathers, their patterns, iridescent colors, the stance of a bird, its quick, often jerky, movements, and, perhaps most taxing of all, the character and articulation of its feet.

Drawing entails learning to see with understanding – the fascinating process of sorting out exactly what it is that you see and wish to convey – and learning how to express this clearly for yourself. This book is all about this process, and the sheer excitement there is to be had from looking at and drawing from living birds, as opposed to merely copying from photographs, often with lifeless results.

Ways of Drawing Birds combines a love of the subject with personal insight and understanding; it gives straightforward, practical, simple information for artists on anatomy, structure, and the sensitive observation of wild birds and their habits with conservation in mind; it shows many drawing techniques in a wide variety of mediums; in fact, it contains just about all that you need to know to get started – so read and enjoy it, and get to work!

Understanding a bird's anatomy It comes as no surprise to discover that the great bird artists, such as John James Audubon and Archibald Thorburn, all made thorough anatomical studies of their subjects. They used them, along with acute observation in the field, to make drawings and paintings that still rank among the best wildlife illustrations made.

Few of us are in a position to emulate these exceptional artists, but having some idea of what makes a bird look the way it does will help you achieve more effective drawings, particularly when you are working on a field trip, in an aviary, or at the zoo, for example.

Many artists rely on photographs when drawing exotic or rare species. This may be the most convenient, perhaps the only, source of visual references you are going to

get of some birds; but no matter how clear and colorful these images may be, they won't tell you that, beneath those massive breast muscles that power its wings, the skeleton is totally inflexible. They won't point out that without its flexible neck, a bird would be unable to preen itself or feed its young, nor that beneath that cloak of feathers there is a pair of muscular legs capable of launching it into the air.

Perhaps most importantly, few photographs are detailed enough to show you the marvelous arrangement of feathers with which a bird so expertly controls its altitude, speed, and flight direction. A basic knowledge of a bird's anatomy will at least provide you with a few clues, to enable you to observe and then translate these elements into lively, descriptive drawings.

Birds' feathers.
Birds control the movement of their feathers to radically alter their body shape. This may be to retain heat, for defense, aggressive display, or even for courtship, which often involves the raising of the crown feathers on the head.

Alula
The bird's "thumb" has its own feathers.

The muscles have little effect on the bird's appearance and are not visible except on ostriches and similar species.

Tail stump
The tail has no muscles or skeleton. The tail feathers are inserted in the stump.

Crop
The esophagus is sometimes visible as a bulge at the base of the neck.

Leg muscles
When a bird is in flight, these muscles are usually hidden beneath the body feathers. However, understanding the particular structure of the leg is vital when drawing a bird landing or moving on the ground.

Feet
Birds' feet have no muscles, and usually no feathers. However, their structure and covering make fascinating subjects for the artist.

The feathers are arranged in distinct groups or tracts, which are found in all species. Color patterns are often related to feather groupings.

Tail shape
Unique to each species, this is an important factor in bird recognition.

Body or contour feathers
The soft, downy body feathers are curved to fit the contours of the bird's body.

Primary feathers
These are the relatively large, aerodynamic feathers that a bird uses for control in the air. Although the number varies, most birds have eight to ten primary feathers on each wing.

Flank, belly, and underside feathers
Each of these forms a distinct group. A central parting line can sometimes be seen on the belly.

Underside of the wing
This may look similar to the top side, but there are major differences between the two.

In addition to the distinctive overall body shapes and plumage with which you can identify various species of birds, heads and feet also carry a wealth of information that enables you to distinguish one bird from another.

Head of an ostrich

Pheasant's foot, showing small rear toe and spur.

Crow's foot, showing the inside of the right foot, plus the underside (left).

Toe detail, showing arrangement of joints and claw.

Head
The bald head of the ostrich shows the features that are covered by feathers on other birds.

Legs and feet
It is worth studying birds' feet (see page 46). The scale pattern, claw shape, toe length and thickness, and toe-pad prominence are all important details.

Although leg shape varies between species, legs are never completely circular. Cormorants and ducks, for example, have thick, blade-like legs.

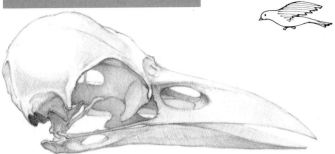

Beaks

The beak, also known as the bill, is not merely a spike stuck onto the bird's face; it is integral to the skull, as can be seen in the drawing of the crow's skull (right).

The shape of the beak varies from species to species. A duck's bill, for example (bottom right), has ridges, folds, flat plains, and curves, while a jackdaw's beak widens dramatically toward the head, displaying a distinctive broad gape (bottom left).

Eye feathers

Grouped in concentric rings (right), they increase in size the further they are from the eyelid. Note also the bristles and ear coverts.

Crow's skull

Facial feathers

Jackdaw's beak

Duck's bill

Give yourself time to study the subject. This does not mean you have to spend hours drawing before you can get good results; just set aside enough time so that you can work undistracted. It is the quality of your observation that counts, rather than the quantity.

Remember that it is not essential to come home with a masterpiece each time you go out sketching. You will achieve far better results if you allow yourself to enjoy the process of drawing for itself, and simply make visual observations of the wildlife around you.

Don't keep rubbing out or obliterating your false starts, and never tear reject pages from your sketchbook. Making mistakes is part of the process, and you will learn more from an awkward drawing that goes wrong than from a slick sketch

that was the easier option. All drawing is valuable experience, regardless of the end result. A good way of understanding birds' anatomy is to study a dead or stuffed bird. This will give you the chance to examine your subject closely. Remember, though, that birds are living creatures, constantly on the move, and dead or stuffed examples on their own are incapable of providing the full picture.

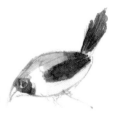

Make life simple for yourself when working outdoors. A large drawing board can be a liability in strong winds, whereas a ringbound sketchbook is easy to carry. Use whatever medium suits you; a pencil is as reliable as anything else.

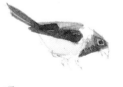

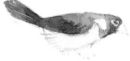

Finally, never allow the enjoyment of your hobby to interfere with the bird you are drawing. Wild birds face enough hazards already!

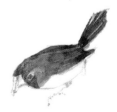

The best way to learn how to draw is by actually drawing, so why not get started? Use whatever you have to hand; a ballpoint pen on the back of an envelope is fine.

Look for the overall shape
Don't get bogged down in detail until you've captured the essential shape of the bird you are observing.

Learning a visual language
Drawing can be like learning a foreign language. Simple shapes, lines, marks, forms – a cryptic alphabet – combine to make a visual vocabulary.

Drawing from life
A quick sketch from a living bird may be more true to life than a feather-by-feather copy of a photograph.

Be objective
Draw what you see rather than what you think you should see. A knowledge of anatomy is useful, but don't allow it to cloud your vision.

If the idea of drawing live birds seems intimidating, get started by drawing stuffed specimens. You can learn a lot about the shape of a bird and the color of its plumage, but remember, stuffing and wire are no substitute for living muscle and sinew. And a stuffed bird will tell you nothing about natural behavior.

One man's vision

No matter how carefully you draw a stuffed bird, it is difficult to make it lifelike. This golden eagle's pose has been dictated by the dimensions of the glass case. It is like trying to understand the human form by drawing mannequins in a department-store window. Taxidermy is something of an art form in its own right, so with a stuffed bird you see someone else's interpretation – this stuffed golden eagle gives an insight into the art of Victorian naturalist Seth Lister Moseley.

Studying plumage
You can learn a lot about plumage from a stuffed specimen. As the bird cannot fly away, you can make detailed studies of the textures and colors of its feathers.

Studying details
Although stuffed specimens may tell you little about the living creature, they provide an ideal opportunity to study details: the beak and feet always seem to create problems for the artist. The scaly feet of the jay have a reptilian look, at variance with the bird's active, warm-blooded nature. They are a clue to a distant ancestry, as fossil evidence suggests that birds are closely related to dinosaurs.

Dead birds are all too easily found, often the victims of road accidents. However, they provide a good opportunity to make a close study of a real bird.

Pencil study

The wing is seen at a foreshortened angle. Its true proportions are lost, but this drawing gives a better impression of the form of the bird than the pen-and-ink drawing (below).

Watercolor study

This was drawn life-size, and the measurements, for example the length of the wing, were taken directly from the bird.

Pen-and-ink study

This illustrates what happens when you portray the relative sizes of the plumage areas without the distorting effects of perspective. The result is an awkward and flat drawing.

Light

The light, through a window from an overcast sky, was ideal for these studies. It created light and shade, that helped describe the form without the harsh contrasts of shadows created by direct sunlight or a single desk lamp.

Dead finch

A study of one of the artist's Bengalese finches. For weeks, she had been less active than her mate, probably due to the effort of egg-laying. (Her mate was originally thought to be male, but "he" then laid an egg!)

Drawing captive birds is perhaps the perfect compromise: you get the experience of studying live creatures, but they can't fly away. If you wish to keep caged birds yourself, take care to buy them from legitimate sources only. Illegal trapping endangers wild birds already threatened by habitat destruction.

Drawing in a pet shop
If you can stand the screeching, a pet shop is a convenient place to draw parrots like these exotic Nanday conures.

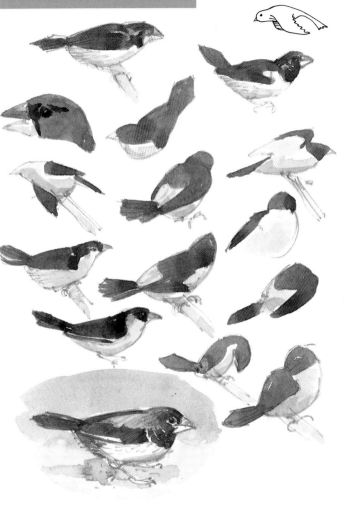

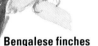

Bengalese finches
These studies of
Bengalese finches
were made as
lightning pencil
sketches. It might
seem to be merely
adding decoration to
add color afterwards,
but, as well as
bringing the page of
sketches to life, this
gives you a second
chance to observe the
bird in each pose.
Having different
poses ready means
that there is every
chance the bird will
resume one of them.

The sketches were
made over a period of
two hours. The birds
divided this time into
bouts of activity,
preening, and rest.

Two approaches to sketching aviary birds

In the main study, more and more detail was added to the drawing of a cock golden pheasant as he strutted about the aviary. You can build up a kind of feather map by this method, but you may lose some of the liveliness seen in the smaller, quick, brush sketches of the hen.

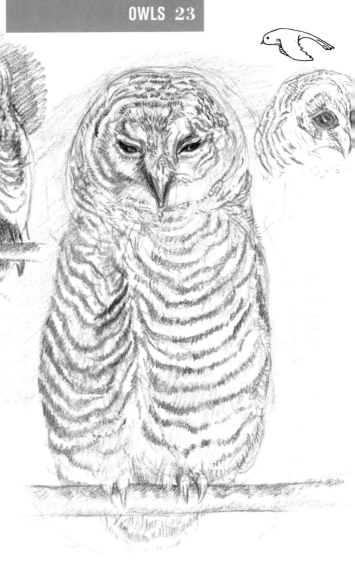

Young tawny owl
Wary of the artist, this young tawny owl held itself up in a position that would disguise it among the dead branches of its woodland home. When relaxed, it resumed the rounded shape typical of owls. This rescued owl chick sleeps on the floor of its cage, with its legs spread out behind it. Like many young birds and animals (including human babies), its eyes have a bluish cast.

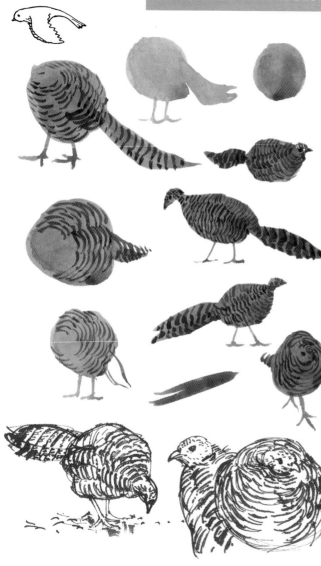

You could spend days recording the subtle camouflage of a hen golden pheasant. The bars of color that break up the outline of the bird in its natural habitat can be used to indicate the form of the bird, like doing a sketch of a zebra by drawing only the stripes.

Making simplified watercolor studies

These simple watecolor sketches were done in two stages: the dark-brown barring was applied over a pale-brown silhouette that had been allowed to dry This technique is only suitable when a bird adopts a similar pose for a while, otherwise lightning sketches in pencil with quick notes about color would be more appropriate.

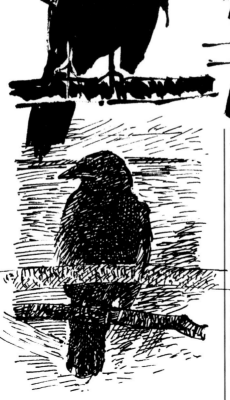

An injured black crow was visible as little more than a silhouette in a dim aviary. These studies were made as rapid line drawings, in brush and pen (top) and pen and ink (right).

Bamboo pen and brush

The drawn outline was filled in with a brush dipped in calligraphy ink, leaving just one or two descriptive highlights, around the eyes, for example. The strong sense of design this method imposes on your work means that you will have to simplify your drawing. Used at full strength, the ink produces a deep, glossy black, but it can take over two hours to dry!

Hatched silhouette

The dimness of the aviary could have been a handicap to drawing. In this pen-and-ink study (left), it contributes to the effect. The "texture" of the darkness is implied behind the strongly hatched image of the bird. Whether this style of drawing captures the character of the crow better than the silhouettes is a matter of opinion.

As A. A. Milne pointed out, "There are some people who begin the zoo at the beginning, called WAYIN, and walk as quickly as they can past every cage until they get to the one called WAYOUT." When it comes to drawing, decide on one animal or bird – here a penguin chick – and produce a page of studies. Work on several pages at once, and add more detail as the bird resumes a pose.

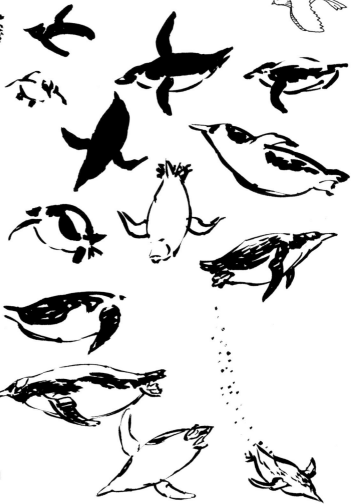

Underwater studies
Plate-glass panels on the side of the penguin pool give a view of penguins in their element.

Swimming penguins are very difficult to capture, partly because their motion is so fluid. Many bird movements, for example a flap of the wings, have a beginning, a middle, and an end to the sequence, allowing the human eye to detect key stages. The penguin's action appears to be seamless as the bird glides across your field of vision, turns, and reappears, gliding in the opposite direction without interruption. Patient observation is the only answer to portraying such movement – you need to spend a lot of time simply looking.

Applying a number of washes
These sketches of Caribbean flamingos were built up with successive washes.

The first was a pale pink wash – the basic color of the flamingo.

When this had dried, the outlines of the birds were sketched in pencil (top left). The green of the background vegetation was added (top right).

Darker red plumes were then indicated on the birds (right).

It is important to think about the marks you are making, and to try and be as descriptive as possible. In general, it is not a good idea to fill a drawing with visual knitting, but crosshatching is the quickest way of filling an area with texture.

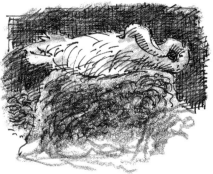

Flamingos
The pen-and-ink sketch shows Caribbean flamingos grouping themselves in their nesting colony. Crosshatching is used in the drawings of individual flamingos on the nest. This shading was much used in Victorian engravings, and it seems appropriate here: an exotic flamingo in the familiar setting of a park is reminiscent of *Alice's Adventures in Wonderland*.

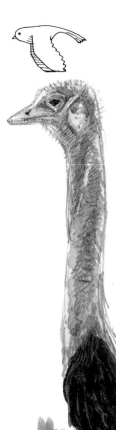

The largest bird

With its somewhat downy plumage, the ostrich resembles a giant-size chick. While this drawing was being made, the bird's neck appeared to change from gray to a blush pink. Was the color of its skin really changing, or was the ostrich raising the small, downy feathers on its neck, revealing more of the color of the skin beneath? It was impossible to tell, but this observation would have been missed if the bird had been drawn from a photograph or from a stuffed specimen.

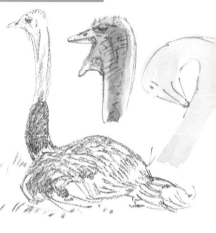

The smallest bird
The hummingbird family includes the smallest of all birds; this violet-ear is one of the larger species. A flying hummingbird is not the most difficult bird to draw – although the wings beat extremely quickly (up to 80 beats per second), the bird's body remains almost motionless as it feeds. However, its plumage is iridescent, so observing color can be tricky.

Because they are so familiar, we tend to ignore domesticated hens, with their plump proportions, and cockerels, in their shimmering ruffs and plumes. In a farmyard, you can experience a scene that has changed little since Rembrandt van Rijn made his sketches of domestic fowl. His lively drawings in brush and pen were influenced by the Oriental tradition of brush drawing, so bamboo pen is a highly appropriate medium.

Brush drawings
Here, you are making the drawing with the brush, not following an outline that you drew earlier. You have to keep looking at the bird at every stage, keeping up your concentration and interest. The results can look fresh and spontaneous.

Bamboo pen
The pen can be difficult to control at first: it tends to blot after each dip in the inkwell, then run dry, leaving faint, scratchy lines. However, this can be an advantage, as it forces you to work freely and decisively; the resulting marks give texture and character to the drawings.

This technique enables you to paint a white bird – here, a silkie – on white paper.

1 Start by painting the space around the bird, in this case a background color that suggests grass.

2 Work on several silhouettes at the same time to allow the background color to dry.

3 Add large blocks of shading on the bird, taking great care to match the color of the shadow. This color is unlikely to be a dull gray; the feathers may have a warm (pale golden-brown, for instance) or cool (bluish) cast. The shaded areas may even be greenish, reflecting color from the grass.

4 Add the darker parts of the shadows and the details of wattles, eyes, and beak, then some suggestion of background detail.

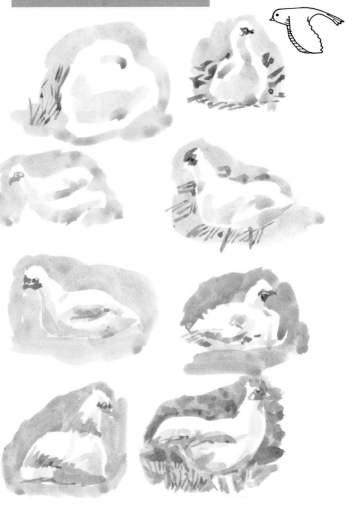

You will need to spend more time looking than sketching to capture flight – watching a flock of house martins, swifts, or swallows circling helps you observe repeated actions. Each attempt to catch the fleeting images on paper will improve your understanding and visual memory. The human eye sees differently from the high-speed camera, and the brain always interprets the received image. You will get convincing results recording this mind's-eye view, rather than using photographs as the basis for studies.

Dipping and diving
The way this swallow dipped and dived into a pond, apparently to drink rather than to catch insects, was something that the artist had not seen before. Unexpected behavior like this is one of the delights of watching and drawing birds.

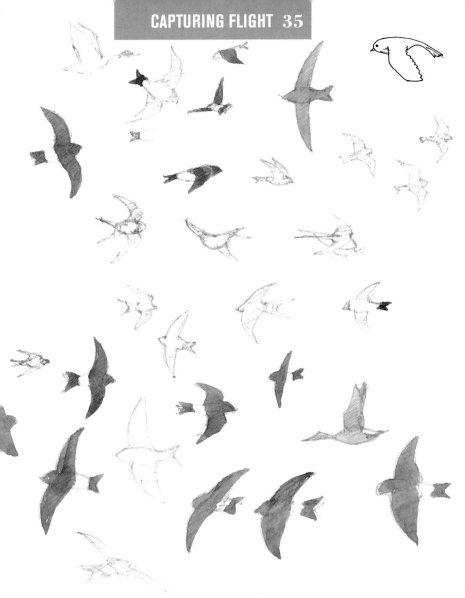

There is so much to be gained from drawing birds in their natural habitat, and depicting them as an integral part of their environment. They have a knack of being in just the right place to create striking compositions, with exciting possibilities for unexpected color combinations.

Drawing the habitat

These two waterside studies were started in watercolor, and worked into with pencil to add fine detail. Texture was applied with paint to give an impression of the foliage, with no attempt to produce a botanical drawing of individual plants.

Adding color later
The mute swan was sketched quickly in pencil as it swam by. The color was added later, and gives no more than an impression of water and a complex pattern of reflections. It is, however, enough to put the swan in a realistic setting. Like the bird itself, the reflections are primarily white paper gleaming through the surrounding paint.

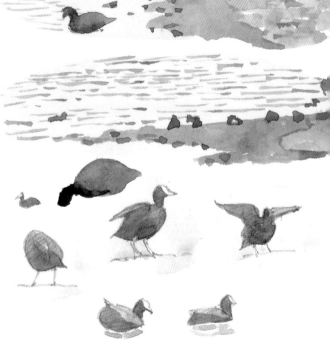

These four little vignettes were worked upon in rotation, so that the first wash on each sketch was dry by the time the artist returned to it.

From light to dark
When using traditional techniques, you start with the lightest tone, often a background color (here, it was the sky reflected in the water), and work through to the darkest. In many cases, the darkest tones are the birds themselves, and by the time you have completed the backgrounds, these most unpredictable creatures may have flown away!

The view from the blind where these particular sketches were made is of a flooded strip mine, landscaped and planted with reed and willow. Even here, you get a true sense of wilderness, and feel in touch with the natural world.

Diverse behavior

These few drawings, made one morning over a period of an hour or so, record such diverse behavior as defending territory, preening, collecting nesting material, and the elaborate courtship ceremony of the grebe.

Coot's habitat

In this view from the blind the coot discourages rivals by chasing them across the water.

Watching and drawing water birds is always relaxing; and trying to record their behavior in your sketchbook makes it challenging. The sketches on these pages were made in pencil, pen and watercolor over a period of one hour and fifty minutes, though not all that time was spent drawing.

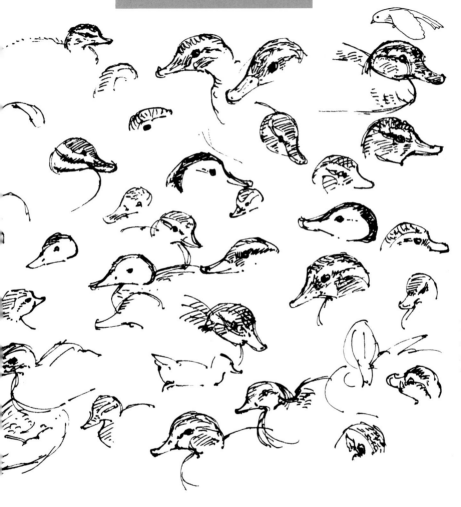

These jottings are fleeting impressions from a short sea-bird cruise. You might notice more if you make quick notes like these. If you later decide to make a finished drawing or painting, perhaps using photographs and bird skins as reference material, you will find that these on-the-spot notes are invaluable.

Drawing from a boat

You will find the motion of the boat and limited time combine to make life difficult when trying to record birds in action at a busy colony. It takes real determination to compile even the sketchiest record.

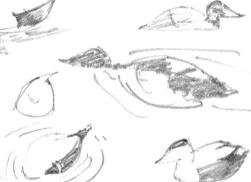

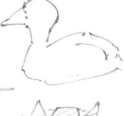

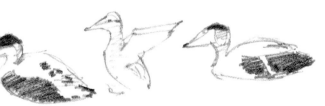

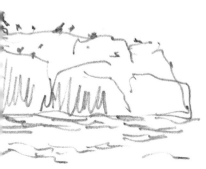

Eider ducks
These eiders were feeding less than 30 yards from where the artist was working. They make a little jump before opening their wings to dive. One came up with a shellfish, and swallowed it whole.

Habits such as preening and sky-pointing (a gannet greeting ceremony) are recorded in these pencil sketches. They were made on Bass Rock, the remnant of an ancient volcano in the Firth of Forth, Scotland, where over 25,000 pairs of gannets nest.

Thoughts for later
Compared with the teeming activity on the rock, the sketch on the left is a feeble record, but it is certainly better than nothing. Visual references like these, including notes on nesting materials, will jog your memory in years to come and bring the day vividly back to life.

These studies were completed little by little as the gannets went about their business – preening, keeping an eye on troublesome neighbors, and taking to the air – during the time the artist was working.

A gradual process

The drawings were first sketched quickly in pencil, with a sepia-wash background to emphasize the white plumage. The larger, colored drawing started out as a study of head and shoulders, but as the gannet obligingly stayed put, the drawing grew to include the whole of the bird. The spear-shaped bill of the gannet is a beautifully subtle shape. Note the absence of external nostrils – an essential adaptation for diving sea birds.

Even artists tend to be selective in what they see when sketching birds. The way a bird cocks its head, spreads its wings, or fans its tail will engage their attention; as with a child's first drawings, the legs and feet are often stuck on as an afterthought. It is worth making studies of birds' legs and feet, to familiarize yourself with them.

Hens' feet
Without feathers, the claws and scales on hens' feet give them a rather reptilian appearance.

Basic stance
However unlikely it may seem, when a bird stands on a flat surface, its feet will be directly below its center of gravity. A bird stands on its toes, with its true knee tucked into its body. A bird's leg is essentially Z-shaped, with the upper stroke of the Z hidden in the plumage. Below that, the tarsus comes forward from what appears to be a backward-bending knee. It is, in fact, the equivalent of the human heel.

Stepping out
When a hen lifts its foot, the tendons pull taut, automatically bunching the toes, as if the hen were contemplating its next move. When the foot hits the ground, the tendons relax again and the foot splays out, acting like a shock absorber.

Drawing legs with a brush

Drawing the legs of a crane or ibis in action is like practicing calligraphy. Like well-proportioned lettering, it's not just the individual marks that are important, but also a feel for the spaces between. The most attractive hand lettering has a natural rhythm to it, and a group of ibis in a dead tree create similar patterns.

These drawings were made with a No 8 sable brush that enabled the artist to work rapidly, to catch the birds' changing attitude and poses.

Attitude of legs

When drawing an end-on view of a bird, be careful to record the attitude of the legs. Does it rest with its lower legs splayed outward from the body, or is it "pigeon-toed," with its toes turned inward?

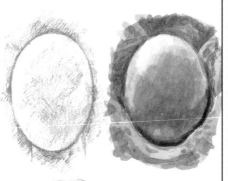

Your local store can provide a classic still-life subject – a hen's or quail's egg. The markings on quails' eggs make them attractive and challenging subjects for drawing and painting.

Don't break the law and endanger wildlife by collecting wild birds' eggs to draw – birds face enough dangers on our overcrowded planet, without additional problems.

Hen's eggs

Describing the smooth curve of an egg on paper is possible, if not easy. It might help to turn your sketchbook around as you work. If you're not happy with your first attempt, don't keep erasing, but settle for the general proportions. Keep a strong image of the egg in your mind; this will help you make a convincing drawing.

Note

The techniques and materials used in the examples shown on this page and opposite are explained in detail on page 52, Basic Essentials.

Quail's eggs
A wide variety of color and pattern can be found on quail's eggs. The shells look as if they are painted, so as well as making straightforward, observational drawings of them, you can experiment with reproducing the blotted, spattered, abstract patterns. Some of the marks have exactly the same color and gloss as brown India ink.

BASIC
ESSENTIALS

The only essential equipment you need for drawing a bird is a pencil and a piece of paper. But, as your experience grows and your skills develop, you will hopefully discover your own drawing style. As this happens, you will probably develop a preference for using particular art materials. In this book you will have seen references to a variety of art terms, materials, and techniques, some of which may be new to you. The following is a glossary of useful information that relates to the artwork featured in this book.

MATERIALS

Graphite pencil
The common, "lead" pencil, available in a variety of qualities and price ranges. The graphite core (lead) is encased in wood and graded, from softness to hardness: 9B is very, very soft, and 9H is very, very hard. HB is the middle-grade, everyday, writing pencil. The H-graded pencils are mostly used for technical work. For freehand drawing work, start around the 2B mark.

Colored pencil
A generic term for all pencils with a colored core. There is an enormous variety of colors and qualities available. They also vary in softness and hardness, but, unlike graphite pencils, this is seldom indicated on the packet.

Watercolor pencil
As above, except water-soluble and capable of creating a variety of "painterly" effects, by either wetting the tip of the pencil or working on dampened paper.

Conté crayon
Often known as conté pencil, and available in pencil or chalk-stick form. Originally a proprietary name that has become a generic term for a synthetic chalk-like medium, akin to a soft pastel or refined charcoal. It is available in black, red, brown, and white, but is best known in its red form.

Steel-nib (dip) pen
The old-fashioned, dip-in-the-inkwell pen, a worthy and versatile drawing instrument. You will need to experiment with nibs for thickness and flexibility. They can take a while to break in and become free-flowing in use. However, the same nib can give a variety of line widths, as the

artist changes the pressure on the pen.

Quill pen
The standard writing and drawing pen for many centuries. See overleaf for making a quill pen.

Bamboo pen
Available from art-supply stores, bamboo pens are trimmed from hollow bamboo shoots, and are quite long-lasting.

Chinagraph
The proprietary brand name of a waxy, waterproof pencil, often used with watercolors.

Drawing ink
Available in a range of colors, there are a variety of drawing inks, from water-soluble writing inks to thick, permanent, and waterproof drawing inks, such as India ink.

Paper
Varies enormously in type, quality, texture, manufacture, and price. Paper is either smooth (hot-pressed, or HP), medium (cold-pressed, or CP), or rough. The smoothness or roughness of a paper is known as the "tooth." The tooth of a paper will influence the way that a medium reacts to it.

Watercolor
Watercolor paint is translucent. It can thus be combined with inks and pencils, to add color and background to a drawing.

TERMS

Drybrush
A drawing effect created by using a brush sparsely loaded with watercolor paint, or a dry, fiber-tip pen. Drybrush allows the texture of the paper or any drawing beneath to show through.

Mixed media
A drawing made using a combination of two or more materials, for example, graphite pencil used with watercolor paint.

Line drawing
A drawing made up purely of lines, with no attempt to indicate shadow or darker areas through shading.

Shading
An indication of shadow or dark areas in a drawing, made by darkening the overall surface of the area, often by rubbing.

Tone
The prevailing shade in a drawing, and its comparative dullness or brightness.

Highlight
The lightest point in a drawing. This is often the point where light strikes an object, such as a reflection in an eye, or on a surface, such as an eggshell.

Hatching
An illusion of shadow, tone, or texture in a

drawing, indicated by linework.

Crosshatching
An illusion of darker shadows, tones, or textures, indicated by overlayering hatched lines at differing angles to each other.

Parallel hatching
Shadows, tones, or textures, indicated by drawing lines next to one another.

Wash
An area of single-color paint painted onto paper. This can cover the entire surface, or be used in smaller areas, for example, to suggest grass, sea, or sky. Flat washes create a uniform color, while graded washes go from the darkest to the lightest shades of the color.

Notes on materials and techniques used for drawing bird's eggs on pages 48-49.
In addition to the Basic Essentials *included previously, the following information will be valuable when trying to capture surface patterns:-*

Highlights
On a white egg, everything but the highlight should be darkened by a tone. The solidity of the egg can be emphasized if you follow the contours with your shading. The artist found it essential to indicate the background on several of his studies to make the light-colored eggs stand out.

Gloss
The slight gloss of the egg gives a reflection of the tonal values in the immediate surroundings. Imagine an egg coated with a mirror finish: this will give you an idea of what to look for.

Watercolor
(page 48)
Working to a pencil outline, the watercolor was worked until it was darker than would be usual. Three colors were used: brick red, yellow ochre, and ultramarine. The white highlight is where the white of the paper has been left unpainted to show through.

Gouache
(page 48)
A white egg takes its colors from its surroundings. In this study, the grays and browns are reflections of the shadows from the room and the papier-mâché egg box, even though the egg itself had a bluish cast. Gouache is opaque watercolor; white is added to transparent colour, to give it body. The light areas in this painting are where white has been added, rather than leaving the white of the paper to show through (see above).

Watercolor pencil
(page 48)
The texture of the paper, emphasized by the crayon shading, suggests the stipple of eggshell. The whiteness of the egg shows up even in the shadow, since this dry technique doesn't flood into the little pits in the surface of the paper. The gradations possible with crayon allow a smoother image than is possible with, say, pen and ink. The secondary, reflected light illuminates the shadow at bottom right of the egg.

Art pen and calligraphy inkink
(page 48)
The smooth lustre of an eggshell is a challenging subject to portray in pen-and-ink line. Some of the marks in this drawing follow the contours of the egg, but crosshatching has been used as a quick way of indicating the shadow.

Dip pen and brown ink
(page 49)
The uneven, blotty character of the line adds animation to this sketch. Waterproof, brown India ink was used, and it was possible to add a watercolor wash, once the ink had dried.

Technical pen and watercolor
(page 49)
You can create a fine, stippled texture with a technical pen, as it produces marks that are consistent in thickness. A pale wash was added to the pen drawing.

NOTE
You can work quickly using a *fountain pen;* the ink flows easily and accurately, because of the sharpness of the line. The drawing technique can thus look more relaxed than using a technical pen, but more carefully observed than with a dip pen.

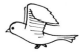

Acrylic and spatter technique
(page 49)

Once set, acrylic paint is completely waterproof, so it is ideal for certain experimental techniques. Here the background colors of the eggs were painted in and allowed to dry. An oval mask was cut in scrap paper (it is easier to cut an oval hole in the paper if you fold it first), and watered-down, brown acrylic was spattered on from a toothbrush by dragging a piece of card across the bristles. The white speckle, that gives a dusty look to the lower egg, was added in a similar way.

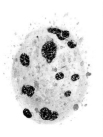

There is something apt about drawing birds with a quill pen. It is easy enough to make your own pens, but take care with the knife!

1 Take a stout, round feather – a goose feather is ideal. Trim back the feather to the stem, so that it is easier to handle.

2 Trim the tip off the feather, using a very sharp knife (this is where the term "penknife" derives from), making a curved, diagonal cut as shown. Remove the keratin filling from the quill.

3 Make a single cut, running up from the tip of the quill. This acts as a channel for the ink.

INDEX OF POSSIBILITIES There are many ways of looking at the world, and there are as many ways of interpreting it. Art and creativity in drawing are not just about "correctness" or only working in a narrow, prescribed manner; they are about the infinite ways of seeing a three-dimensional object and setting it down.

In the earlier sections of this book, the consultant artist demonstrated the different approaches to drawing a specific subject. His examples show how he has developed a personal way of seeing and setting down birds on paper.

The following section of images is intended to further help you discover and develop your own creativity. It is an index of possibilities: an indication of just some of the inventive and inspirational directions that creative artists have taken,

and continue to take. This visual glossary demonstrates how the same subject can be treated in a variety of ways, and how different cultures and artistic conventions can affect treatments.

In every culture and age, symbols and simplified images are vital factors in communication. The earliest cave drawings reduce the forms of men and animals to the basics, and tell an immediate story; similarly, modern advertising campaigns and computer-based corporate trademarks depend on our instant recognition of simplified forms. The graphic images in this section show how the artist's eye and hand can produce universally understood forms in all human societies.

A major part of artistic and technical development is being aware of, and open to, possibilities from outside your chosen sphere. To that end, the images in this section use a wide variety of materials and techniques. They may not all be pure "drawing," but each one expands the boundaries of what is possible, and provides new ways of seeing and interpreting birds.

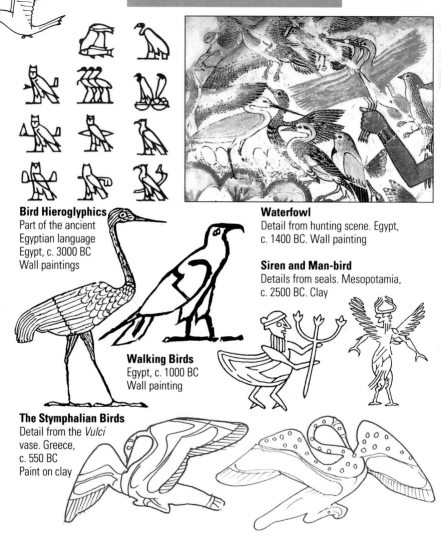

Bird Hieroglyphics
Part of the ancient
Egyptian language
Egypt, c. 3000 BC
Wall paintings

Waterfowl
Detail from hunting scene. Egypt,
c. 1400 BC. Wall painting

Siren and Man-bird
Details from seals. Mesopotamia,
c. 2500 BC. Clay

Walking Birds
Egypt, c. 1000 BC
Wall painting

The Stymphalian Birds
Detail from the *Vulci*
vase. Greece,
c. 550 BC
Paint on clay

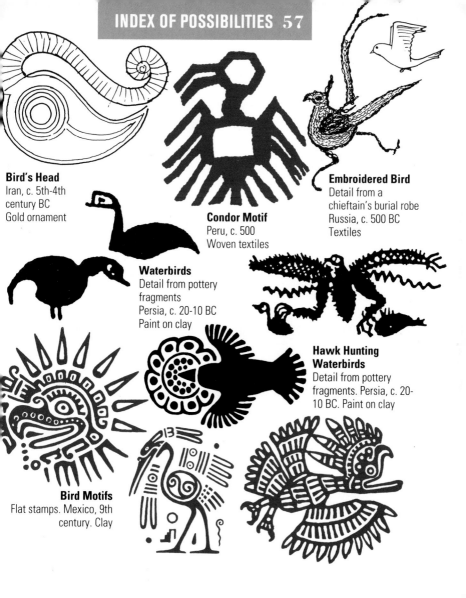

Bird's Head
Iran, c. 5th-4th
century BC
Gold ornament

Condor Motif
Peru, c. 500
Woven textiles

Embroidered Bird
Detail from a
chieftain's burial robe
Russia, c. 500 BC
Textiles

Waterbirds
Detail from pottery
fragments
Persia, c. 20-10 BC
Paint on clay

**Hawk Hunting
Waterbirds**
Detail from pottery
fragments. Persia, c. 20-
10 BC. Paint on clay

Bird Motifs
Flat stamps. Mexico, 9th
century. Clay

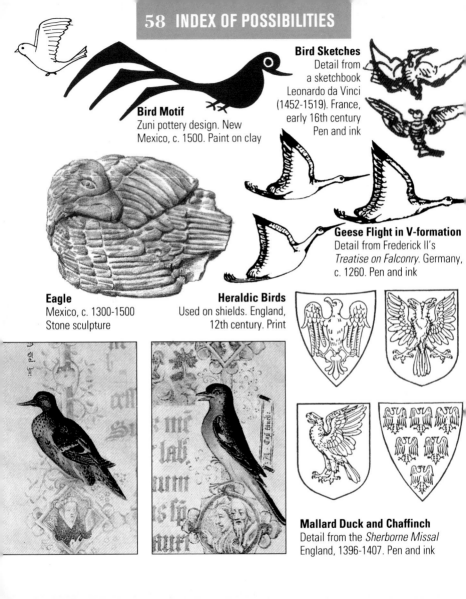

Bird Motif
Zuni pottery design. New Mexico, c. 1500. Paint on clay

Bird Sketches
Detail from a sketchbook Leonardo da Vinci (1452-1519). France, early 16th century Pen and ink

Geese Flight in V-formation
Detail from Frederick II's *Treatise on Falconry*. Germany, c. 1260. Pen and ink

Eagle
Mexico, c. 1300-1500 Stone sculpture

Heraldic Birds
Used on shields. England, 12th century. Print

Mallard Duck and Chaffinch
Detail from the *Sherborne Missal* England, 1396-1407. Pen and ink

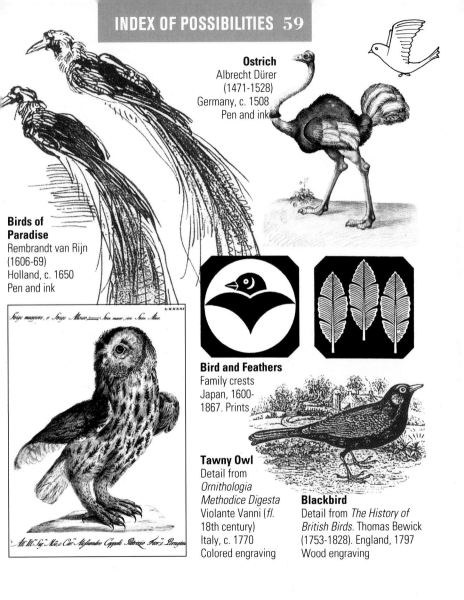

Ostrich
Albrecht Dürer
(1471-1528)
Germany, c. 1508
Pen and ink

**Birds of
Paradise**
Rembrandt van Rijn
(1606-69)
Holland, c. 1650
Pen and ink

Bird and Feathers
Family crests
Japan, 1600-
1867. Prints

Tawny Owl
Detail from
*Ornithologia
Methodice Digesta*
Violante Vanni (*fl.*
18th century)
Italy, c. 1770
Colored engraving

Blackbird
Detail from *The History of
British Birds*. Thomas Bewick
(1753-1828). England, 1797
Wood engraving

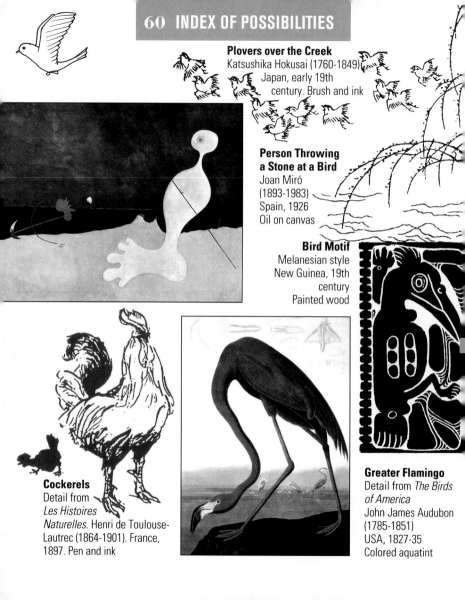

Plovers over the Creek
Katsushika Hokusai (1760-1849).
Japan, early 19th
century. Brush and ink

**Person Throwing
a Stone at a Bird**
Joan Miró
(1893-1983)
Spain, 1926
Oil on canvas

Bird Motif
Melanesian style
New Guinea, 19th
century
Painted wood

Cockerels
Detail from
*Les Histoires
Naturelles*. Henri de Toulouse-
Lautrec (1864-1901). France,
1897. Pen and ink

Greater Flamingo
Detail from *The Birds
of America*
John James Audubon
(1785-1851)
USA, 1827-35
Colored aquatint

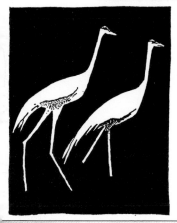

Two Birds
Bushman painting
Basutoland,
c. 1900. Paint

Holy Spirit as Dove
Detail from *The Song of
Songs*. Eric Gill (1882-1940)
England, 1925. Woodcut

Group of Birds
From *Park Scene*. Henri Gaudier-Brzeska
(1891-1915). Paris, 1912. Pen and ink

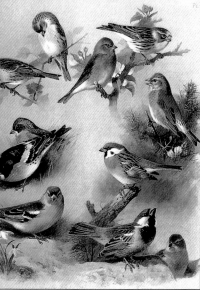

The Finches
From *British Birds*
Archibald Thorburn
(1860-1935)
England, 1915
Watercolor

Dog and Cock
Pablo Picasso
(1881-1973)
France, 1921
Oil on canvas

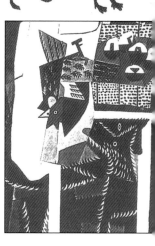

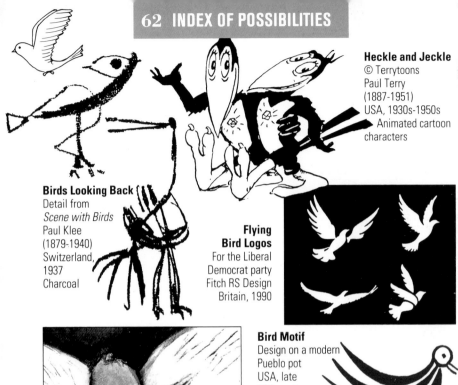

Heckle and Jeckle
© Terrytoons
Paul Terry
(1887-1951)
USA, 1930s-1950s
Animated cartoon
characters

Birds Looking Back
Detail from
Scene with Birds
Paul Klee
(1879-1940)
Switzerland,
1937
Charcoal

**Flying
Bird Logos**
For the Liberal
Democrat party
Fitch RS Design
Britain, 1990

Bird Motif
Design on a modern
Pueblo pot
USA, late
20th century
Paint on clay

Rooster Logo
For the Pathé film
company
Wolff Olins
France, 1993

Bird's Eye
From *The Juggler*. Marc Chagall (1887-1985)
France, 1943. Oil on canvas

African Bird
Detail from *Elephant Head*. Thamae Setshogo (*fl.* 20th century) Botswana, 20th century. Woodblock print

The Pelican and Her Young
Eric Gill (1882-1940) England, 1939 Woodcut

The Roadrunner
© Warner Brothers Chuck Jones (b. 1914) USA, 1948-69 Animated cartoons and comics

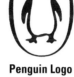

Penguin Logo
For Penguin books. England, late 1930s. Print

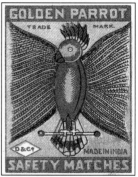

Parrot Motif
Matchbox label India, 20th century. Print

Flying Birds
Maquette for exhibition catalog. Georges Braque (1882-1963) France, 1956. Oil on paper

Eagle Logo
For the *Independent* newspaper Britain, 1987

Bird and Insects
Saul Steinberg (b. 1914). USA, 1950s. Pen and ink

CONTRIBUTORS AND CONSULTANTS

Contributing artist

Richard Bell's interest in birds began when he was given a book of bird illustrations on his seventh birthday; inspired by this, he won a British national competition with a book of his bird drawings and paintings. He was the first student to graduate from the Natural History Illustration course at the Royal College of Art; since then, he has advised on natural history and worked on feature films, and has appeared on television programs about environmental education and location painting. He is the author and illustrator of two books, *Richard Bell's Britain* and *Down in the Wood*, and is the contributing artist to *Ways of Drawing Cats* in this series. He has exhibited at the Victoria and Albert Museum and the Natural History Museum in London.

Natural history illustration advisor

John Norris Wood is the founder and Head of the Natural History Illustration Department at the Royal College of Art in London. He is also a freelance wildlife artist, writer, and photographer, an expedition leader in America and Africa, and a keen and active conservationist.

SOURCES/BIBLIOGRAPHY

In addition to the original artwork shown in this book, many books, journals, printed sources, galleries, and collections have been consulted in the preparation of this work. The following will be found to make useful and pleasurable reading in connection with the history and development of the art of drawing birds:

Animals and Men, K. Clark, Thames & Hudson, 1977
Animals in Art, J. Rawson, BMP, 1977
Animals in Art and Thought,
P. Klingender, Routledge & Kegan Paul, 1971
The Atlas of Early Man,
J. Hawkes, St. Martin's Press, 1976
Birds in Medieval Manuscripts,
B. Yapp, British Library, 1981
Chagall, A. Herald, Magna, 1993
Classic Natural History Prints: Birds,
S. Dance, Collins & Brown, 1990
A Complete Guide to Heraldry, Nelson, 1951
Cubism, Thames & Hudson, 1984
Design magazine, August 1993
Drawings, S. Steinberg, Allen Lane, 1962
Drawings from Ancient Egypt,
H. Peck, Thames & Hudson, 1978
Egyptian Language, F. Budge, Dover, 1983
The Encyclopedia of Comic Books,
R. Goulart, Time as Art, 1990
Eric Gill: The Engravings , C. Skelton, Herbert Press, 1990
Handbook of Designs and Motifs, Tudor, 1950
Hokusai: Sketches and Paintings, Kodansha, 1969
Joan Miró, W. Erben, Benedikt Taschen, 1988
Leonardo da Vinci, J. Williams, Cassell, 1965
The Master Draughtsmen: Rembrandt,
The Studio Ltd., 1933
Masterpieces of Primitive Art,
D. Newton, Thames & Hudson, 1980
Paul Klee, M. Plant, Thames & Hudson, 1987
Primitive Art, L. Adam, Penguin, 1949
Primitive Art, J. Christensen, Thames & Hudson, 1955
Tapestry, Mirror of History,
R. Thompson, David & Charles, 1980
Thorburn's Birds and Mammals,
J. Southern, David & Charles, 1986
Toulouse-Lautrec,
P. Huisman and M. Dortu, Thames & Hudson, 1973
Woodcuts by Thomas Bewick and His School,
B. Cirker, Dover, 1962